SCHITT
HAPPENS

D1303783

SCHITT HAPPENS

An Unofficial Coloring Book for Fans of *Schitt's Creek*

VALENTIN RAMON

ULYSSES PRESS

Published in the United States by:
Ulysses Press
PO Box 3440
Berkeley, CA 94703
www.ulyssespress.com

ISBN: 978-1-64604-256-2

Printed in the United States by Kingery Printing Company
10 9 8 7 6 5 4 3 2 1

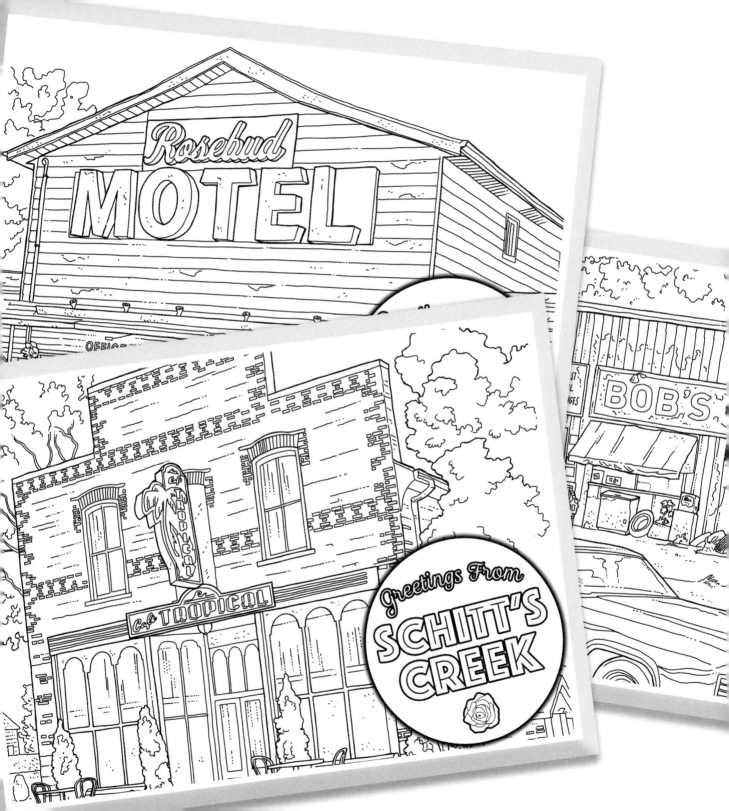

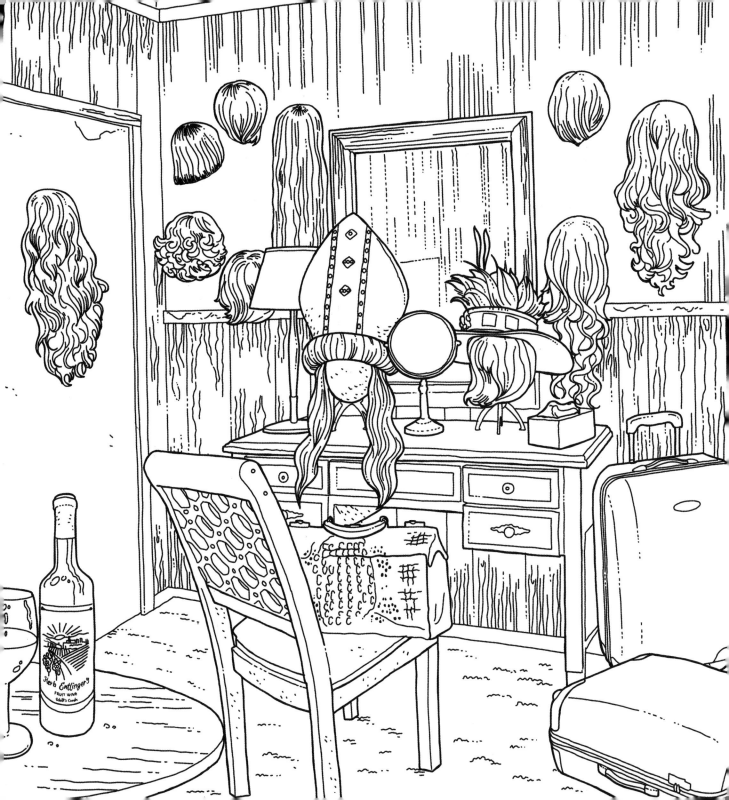

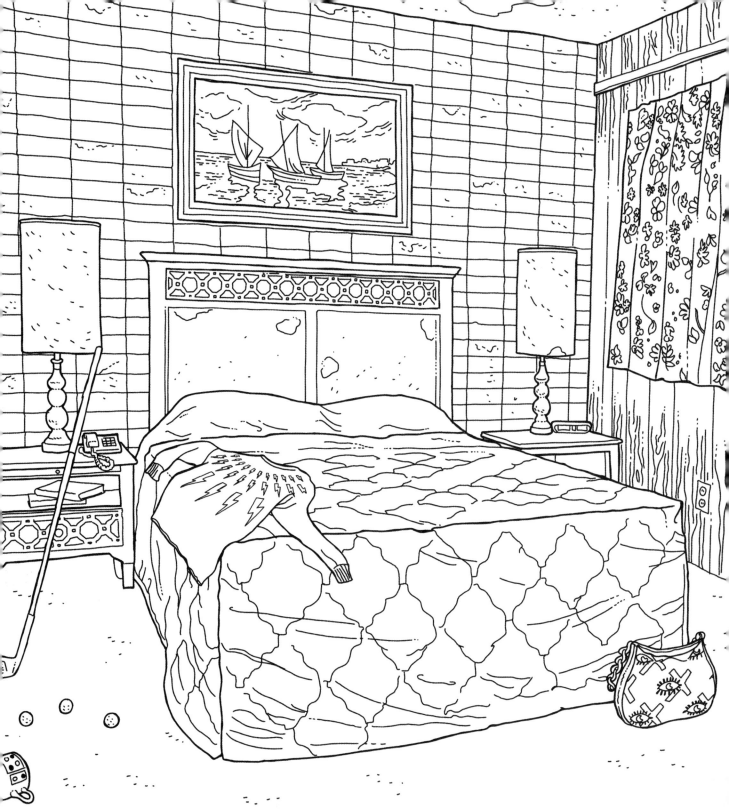

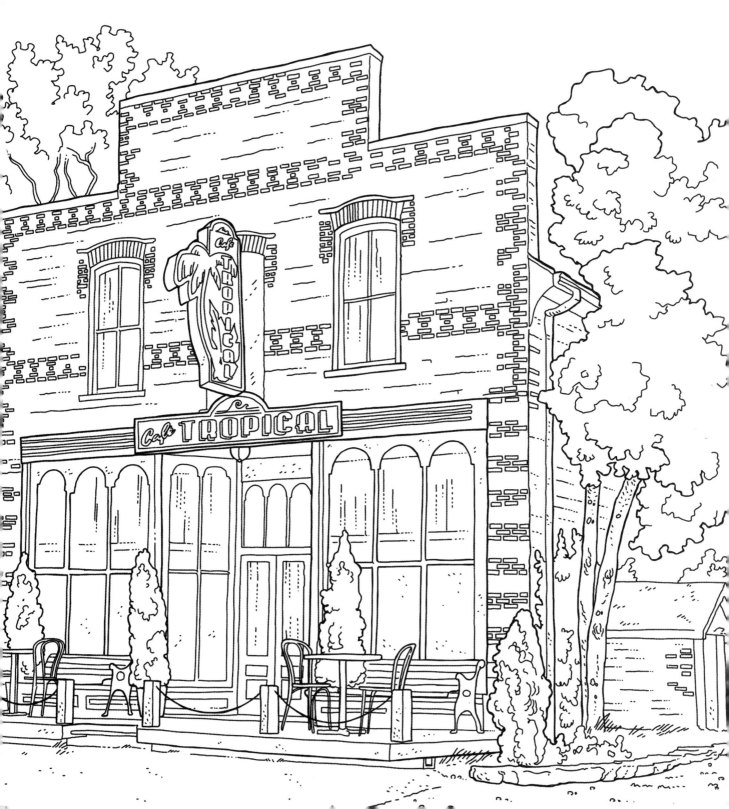

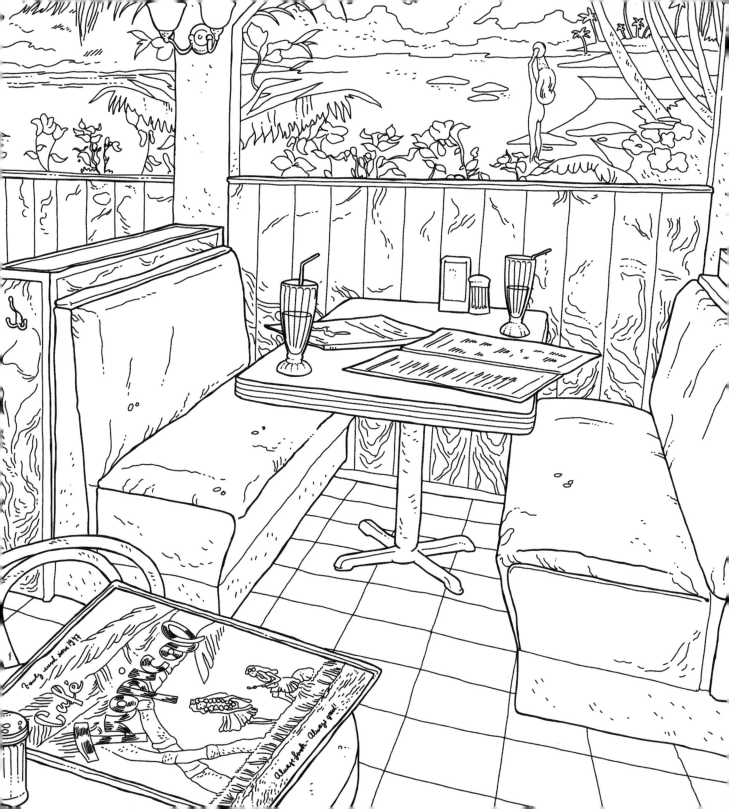

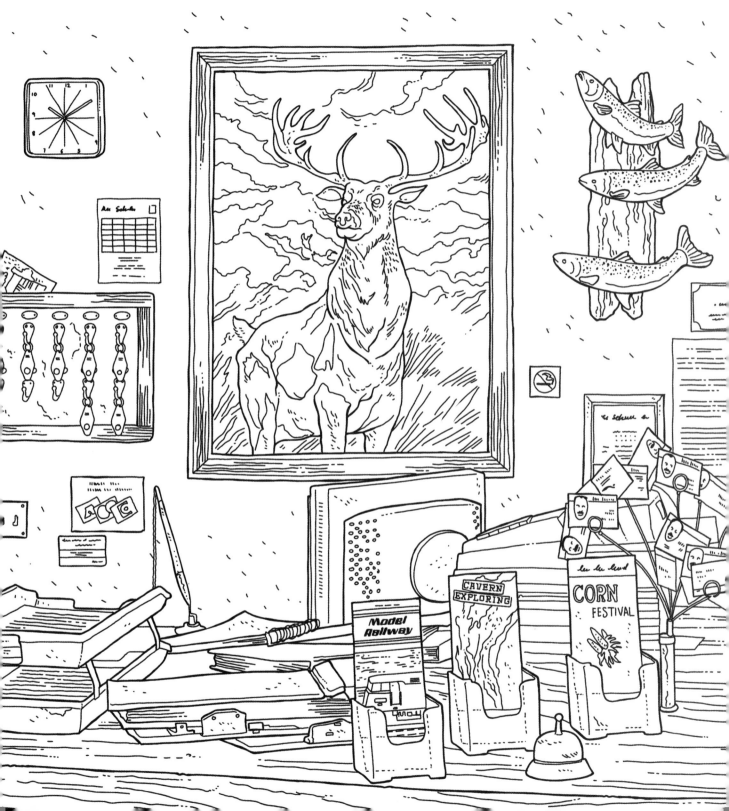

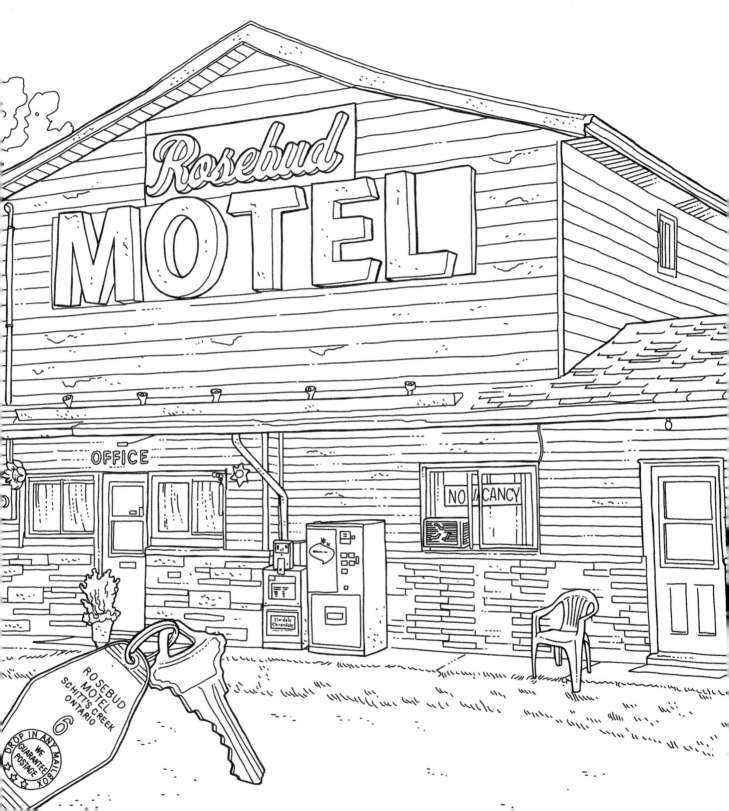

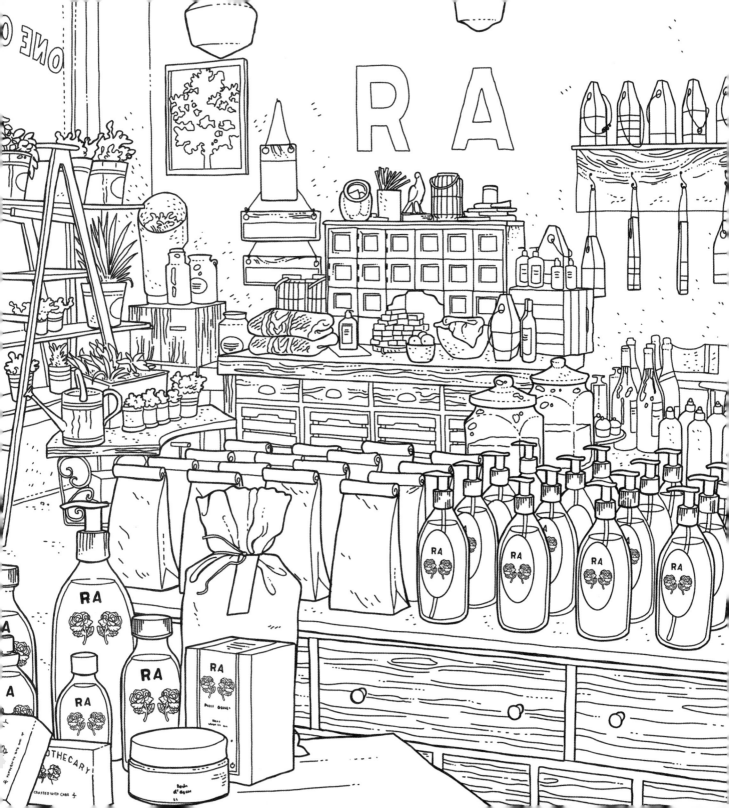

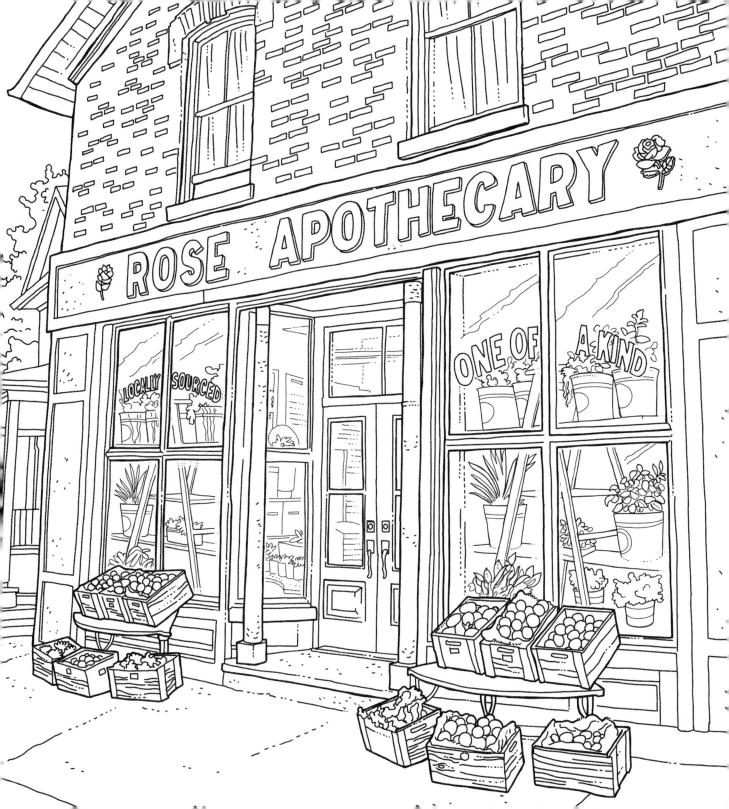

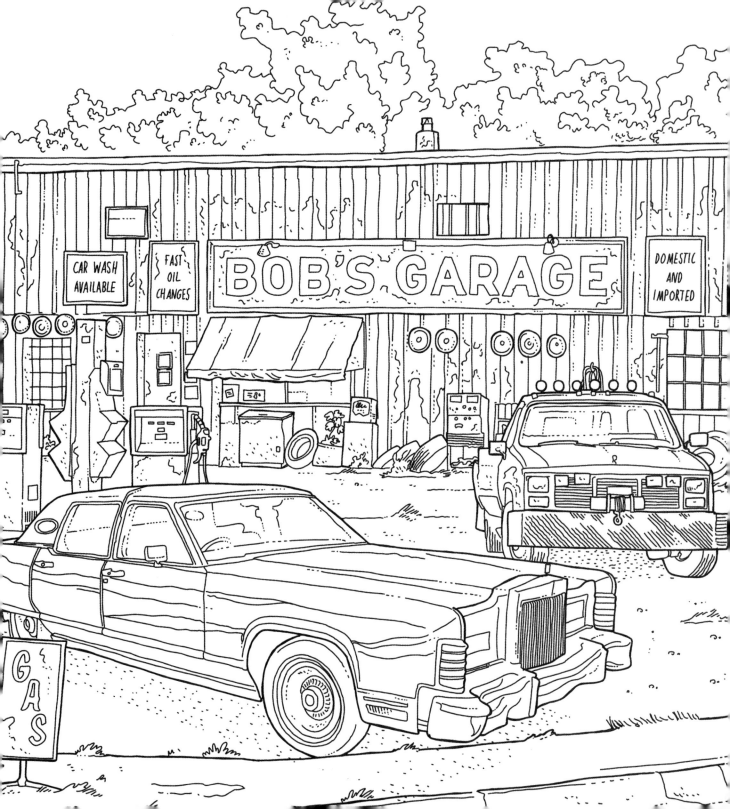

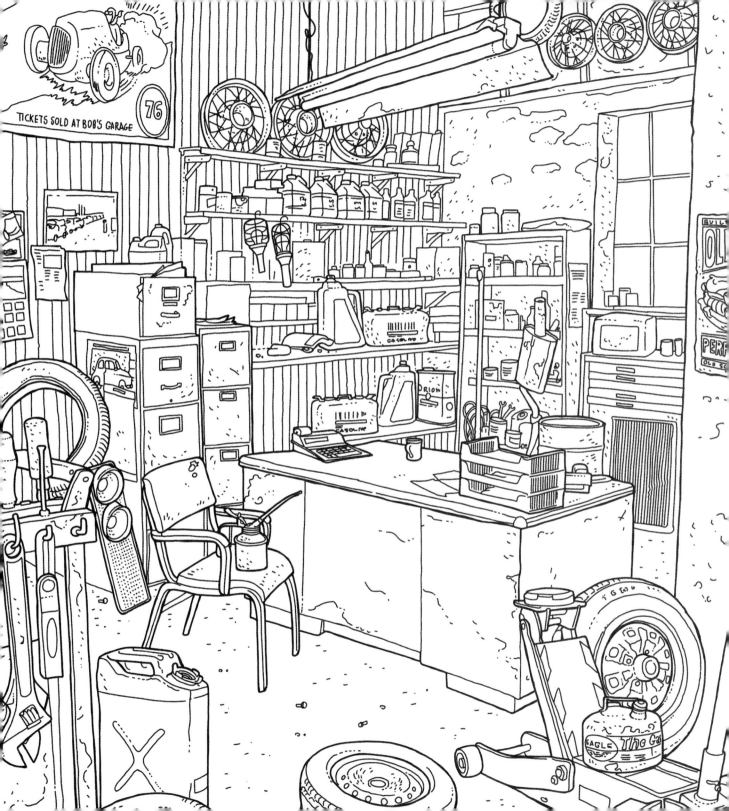

TICKETS SOLD AT BOB'S GARAGE

76

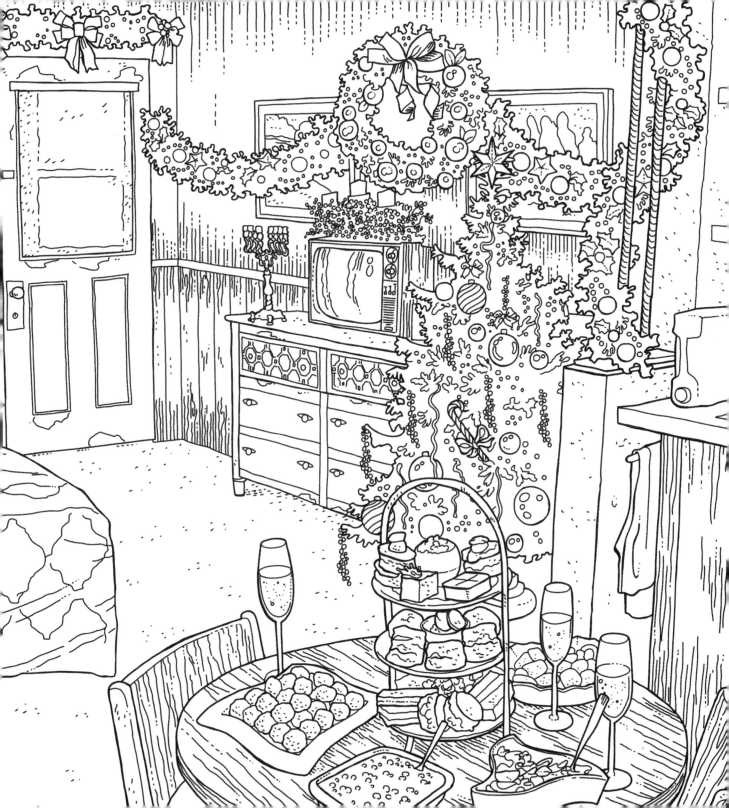

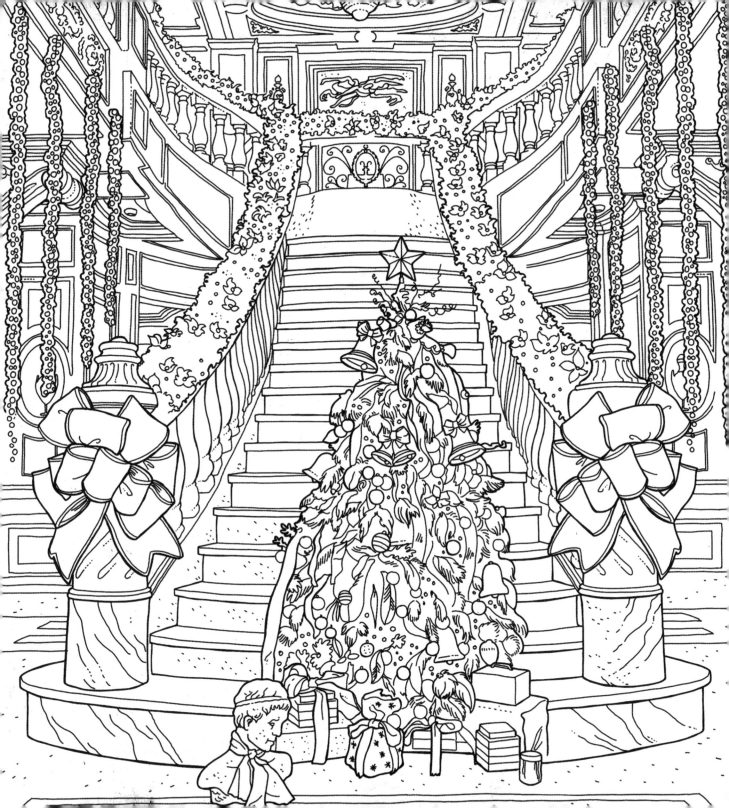

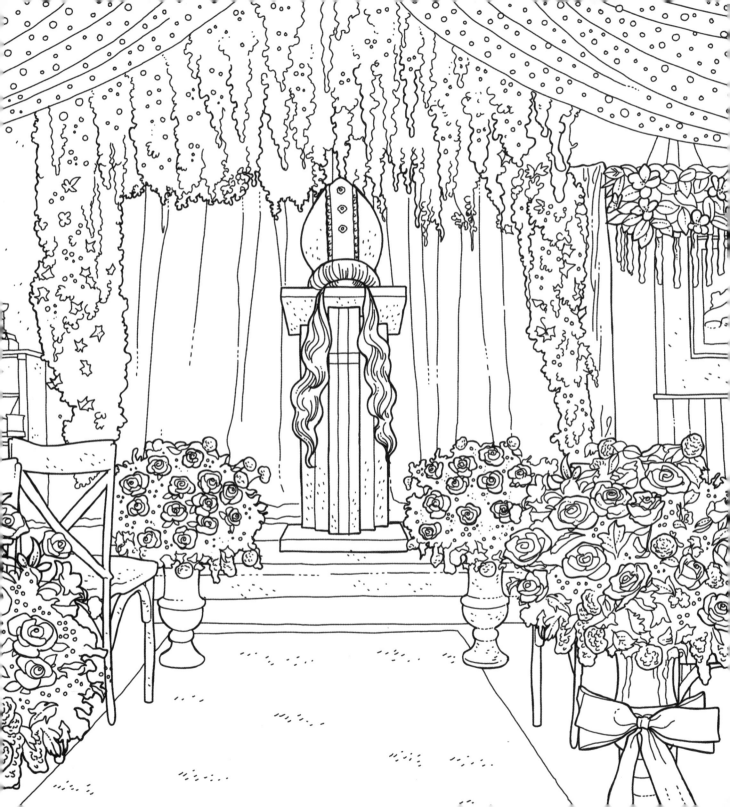

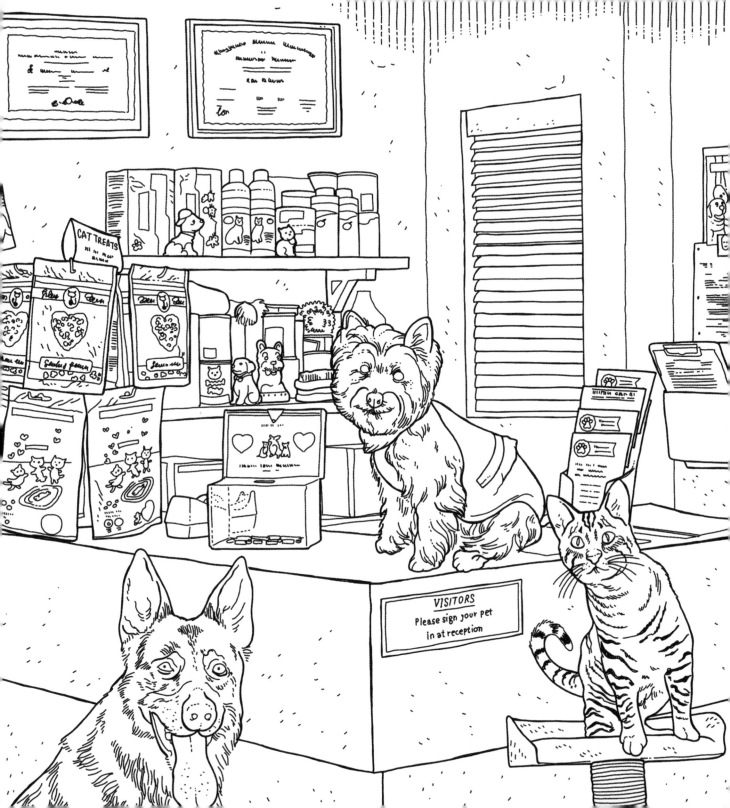

CAT TREATS

VISITORS
Please sign your pet
in at reception

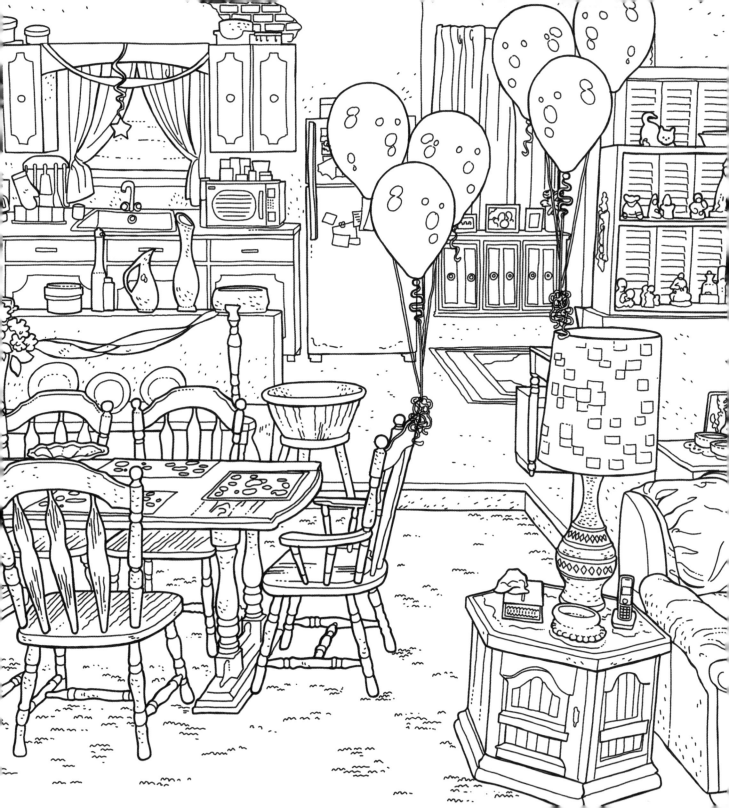

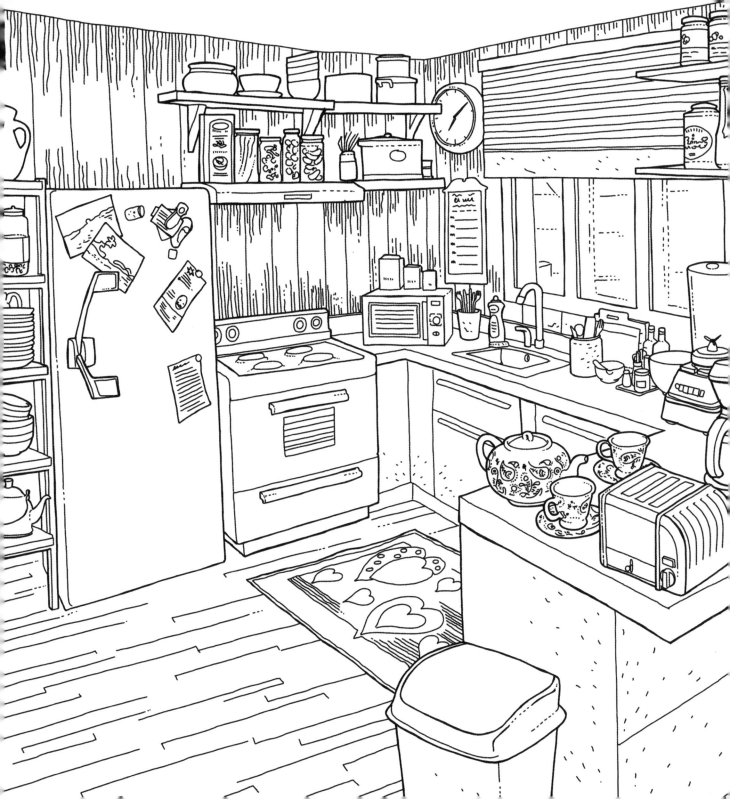

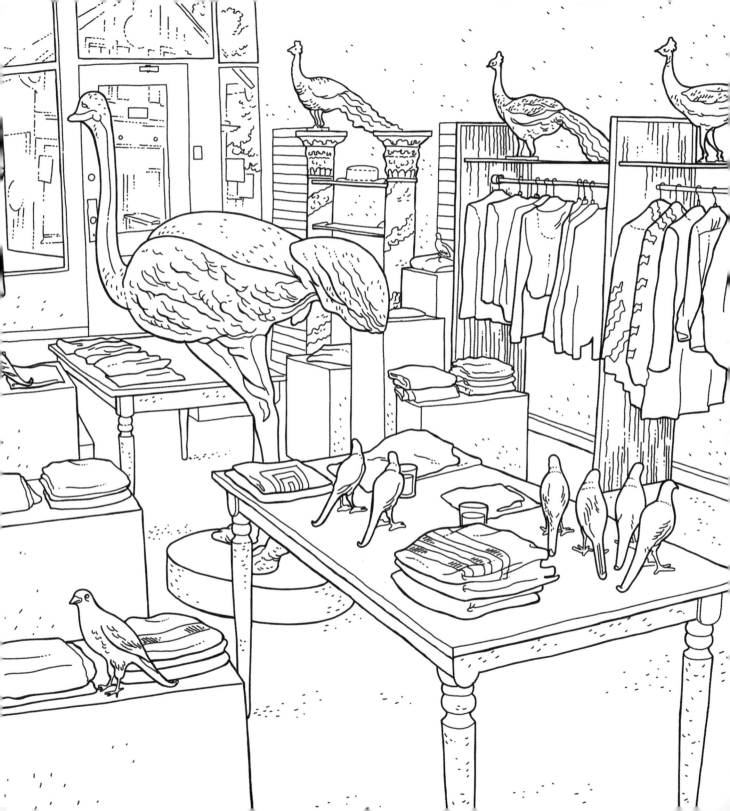

Rosebud
MOTEL

About the Illustrator

Valentin Ramon is a Spanish illustrator living in London, United Kingdom. His coloring books include:

Welcome to Scranton,
The One with All the Coloring,
and *Social Season*.

DISCOVER MORE GREAT COLORING BOOKS FROM ULYSSES PRESS

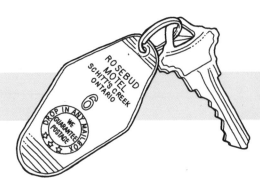

www.ulyssespress.com/coloring